MONEY
THE GAMESHOW

BY CLARE DUFFY

MONEY the game show was first performed at the Bush Theatre, London on 31 January 2013

Cast:
Casino: **Brian Ferguson**
Queenie: **Lucy Ellinson**

Writer / Director – **Clare Duffy**
Designer – **Rhys Jarman**
Lighting Designer – **Richard Godin**
Sound Designer – **Matt Angove**
Composer – **David Edwards**
Production Manager – **Jessica Harwood**
Technical Manager – **Neil Hobbs**
Stage Manager – **Simon Perkins**
Costume Supervisor – **Lydia Hardiman**
Assistant Stage Manager – **Hannah Partington**
Tango Choreography – **Bianca Vrcan** (rojoynegroclub.com)

An Unlimited Theatre and Bush Theatre co-production
Supported by the Simon Gray Award and Arts Council England

Originally developed as part of the Platform 18 Award in partnership with The Arches, Traverse Theatre, National Theatre of Scotland and Creative Scotland.

WRITER'S ACKNOWLEDGEMENTS

I interviewed a number of experts in their fields as part of the research process for this play. I take complete responsibility for all opinions and facts presented in it, but I would very much like to thank Michael Alen-Buckley, Executive Chairman at RAB Capital, Jonathan Ford at *Financial Times*, Justin Shinebourne at Barclays, Stephen Robertson at TDR Capital and Dr Stephen Gruneberg, Reader in the Department of Architecture and the Built Environment, for being so generous with their time and knowledge.

I also want to thank Jackie Wylie and Abigail McMillan at The Arches, my mentor Nick Bone, Pauline Lockheart - the first 'Queenie', and everyone at The Arches, Traverse Theatre, and National Theatre of Scotland involved in the Platform 18 award where this show began its life.

I am hugely grateful to everyone at The Bush, in particular Madani Younis, Omar Elerian and Rachel Tyson and to my colleagues at Unlimited Theatre – Emma Rees, Jon Spooner, Chris Thorpe and Ric Watts for their support in taking *MONEY the game show* to full production. Also sincere thanks all at the Simon Gray Award, and to Andrew Walby and all at Oberon.

Finally, I would like to thank Tom Duffy for encouraging me to find economics exciting, Patricia Duffy for the inspiration to find the source of a good story everywhere and Valerie Blanc for making everything brilliant.

Additional Thanks
Unlimited Theatre would like to thank Arts Council England, everybody at our resident venue West Yorkshire Playhouse, our board of directors for their ongoing support our work, and Analogue for the loan of the AV equipment.

Unlimited Theatre

"The excellent Unlimited Theatre... a company that has always combined infinite thoughtfulness with theatrical flair." **The Guardian**

Based in Leeds UK, Unlimited is what happens when the artists Clare Duffy, Jon Spooner and Chris Thorpe make new work together. This work is always co-created with equal partnership in the creative process and in collaboration with an expanding pool of associate artists, scientists, technologists and educators. At its heart is a sincere engagement with its audience both in the process and moment of (co)creation.

Our work is always for live performance, most often happening in theatres. Increasingly however, our work is being made with a 'cross-platform curiosity' – that is, with a desire to make and distribute the work in other places (e.g. for broadcast and on the internet) but still and always with an emphasis on the 'liveness' of that experience for our audiences.

The company formed in 1997 and has earned a reputation for making consistently brilliant new work. Notable productions during the last 16 years include: *Static*, *Neutrino* (both Fringe First winners), *Zero Degrees and Drifting*, *Tangle*, *The Ethics of Progress*, *The Moon The Moon*, *Mission To Mars* and most recently *The Giant & The Bear* for the London 2012 Festival.

Unlimited has toured extensively in the UK and overseas at international festivals and venues in South Africa, Germany, Zimbabwe, The Philippines, Papua New Guinea, Singapore and the USA.

Recent awards for the company include: Sir Arthur Clarke Award for Achievement in Space Education and Outreach 2011; National Charity Awards 2011 (Arts, Culture and Heritage); and WISE Champion Award 2011.

Unlimited Theatre is resident company at West Yorkshire Playhouse in Leeds, a member of ITC and is part of Arts Council England's National Portfolio of Organisations.

After MONEY the game show, Unlimited make a new show The Noise, a co-production with Northern Stage in Autumn 2013.

unlimited.org.uk
@untheatre

For Unlimited Theatre
Creative Director and Founding Member – **Jon Spooner**
Co-Director and Founding Member – **Clare Duffy**
Co-Director and Founding Member – **Chris Thorpe**
Executive Director – **Emma Rees**
Producer – **Ric Watts**
Administrator – **Alison McIntyre**
Bookkeeper – **Alex Smith**

Board of Directors
Jane MacPherson, Liz Margree, Louisa Riches (chair), Tony Singh, Martin Sutherland

b

BUSH THEATRE

The Bush Theatre is a world-famous home for new plays and an internationally renowned champion of playwrights and artists. Since its inception in 1972, the Bush has pursued its singular vision of discovery, risk and entertainment from a distinctive corner of West London. Now located in a recently renovated library building on the Uxbridge Road in the heart of Shepherds Bush, the theatre houses a 144-seat auditorium, rehearsal rooms and a lively café bar.

The Bush Theatre
7 Uxbridge Road
London, W12 8LJ
Box Office: 020 8743 5050
Administration: 020 8743 3584
email: info@bushtheatre.co.uk
www.bushtheatre.co.uk

The Alternative Theatre Company Ltd (The Bush Theatre) is a registered charity and a company limited by guarantee.

Registered in England No. 1221968.
Charity No. 270080

THANK YOU
TO OUR SUPPORTERS

The Bush Theatre would like to extend a very special 'Thank You' to the following Patrons, Corporate Supporters and Trusts & Foundations whose valuable contributions continue to help us nurture, develop and present some of the brightest new literary stars and theatre artists.

LONE STAR
Gianni Alen-Buckley
Michael Alen-Buckley
Steffanie Brown
Francois & Julie Buclez
Siri & Rob Cope
Jonathan Ford & Susannah Herbert
Catherine Johnson
Caryn Mandabach
Miles Morland
Lady Susie Sainsbury
James & Virginia Turnbull
John Paul Whyatt

HANDFUL OF STARS
Anonymous
Micaela Boas
Jim Broadbent
Philip & Tita Byrne
Sarah Cooke
Clyde Cooper
Irene Danilovich
Catherine Faulks
Chris & Sofia Fenichell
Kate Groes
Simon & Katherine Johnson
Paul & Cathy Kafka
Nicolette Kirkby
Pierre Lagrange & Roubi L'Roubi
Mark & Sophie Lewisohn
Adrian & Antonia Lloyd
Eugenie White & Andrew
Loewenthal
Scott & Laura Malkin
Peter & Bettina Mallinson
Charlie & Polly McAndrew
Paige Nelson
Georgia Oetker
Bianca Roden
Naomi Russell
Charles & Emma Sanderson
Joana & Henrik Schliemann
Jon & NoraLee Sedmak
Larus Shields
The van Tulleken family
Trish Wadley
Charlotte & Simon Warshaw
John & Amelia Winter

RISING STARS
Anonymous
Melanie Aram
Nick Balfour
Tessa Bamford
David Bernstein & Sophie Caruth
Simon & Lucy Berry
John Bottrill
David Brooks
Karen Brost
Maggie Burrows
Clive Butler
Matthew Byam Shaw
Benedetta Cassinelli

Tim & Andrea Clark
Claude & Susie Cochin de Billy
Angela Cole
Matthew Cushen
Michael & Marianne de Giorgio
Yvonna Demczynska
Charles Emmerson
Jane & David Fletcher
Lady Antonia Fraser
Sylvie Freund-Pickavance
Vivien Goodwin
Sarah Griffin
Hugh & Sarah Grootenhuis
Mr & Mrs Jan Gustafsson
Martin & Melanie Hall
Sarah Hall
Giselle Hantz
Giles Haughton
Hugo & Julia Heath
Urs & Alice Hodler
Bea Hollond
Zaza Jabre
Philip Jones
Ann & Ravi Joseph
Davina & Malcolm Judelson
Rupert Jolley & Aine Kelly
Kristen Kennish
Sue Knox
Kirsty Lang
Caroline Mackay
Isabella Macpherson
Michael McCoy
Judith Mellor
Caro Millington
Miles Montgomerie
Kate Pakenham
Kevin Pakenham
Denise Parkinson
Mark & Anne Paterson
Julian & Amanda Platt
Lila Preston
Radfin Courier Service
Kirsty Raper
Clare Rich
Joanna & Michael Richards
Sarah Richards
Robert Rooney
Claudia Rossler
Karen Scofield & LUCZA
Russ Shaw & Lesley Hill
Justin Shinebourne
Saleem & Alexandra Siddiqi
Melanie Slimmon
Brian Smith
William Smith-Bowers
Sebastian & Rebecca Speight
Nick Starr
Andrew & Emma Sutcliffe
The Uncertainty Principle
Ed Vaizey
Marina Vaizey
Francois & Arrelle von Hurter

Hilary Vyse & Mark Ellis
Amanda Waggott
Olivia Warham
Dame Harriet Walter
Peter Wilson-Smith & Kat Callo
Alison Winter
Jessica Zambeletti

CORPORATE SUPPORTERS
SPOTLIGHT
John Lewis, Park Royal
Walt Disney & Co Ltd

LIGHTBULB
The Agency (London) Ltd
AKA
Mozzo Coffee & La Marzocco
Talk Talk Ltd

The Bush would also like to thank Markson Pianos, Westfield and West 12 Shopping & Leisure Centre

We would also like to thank Ogilvy & Mather for sponsoring FEAR and Kudos Film & Television for support of our Literary programme.

TRUSTS AND FOUNDATIONS
The Andrew Lloyd Webber
Foundation
Coutts Charitable Trust
The Daisy Trust
The D'Oyly Carte Charitable Trust
EC&O Venues Charitable Trust
The Elizabeth & Gordon Bloor
Charitable Foundation
Foundation for Sport and the Arts
Garfield Weston Foundation
Garrick Charitable Trust
The Gatsby Charitable Foundation
The Goldsmiths' Company
The Harold Hyam Wingate
Foundation
Jerwood Charitable Foundation
The J Paul Getty Jnr Charitable Trust
The John Thaw Foundation
The Laurie & Gillian Marsh
Charitable Trust
The Leverhulme Trust
The Martin Bowley Charitable Trust
The Thistle Trust
The Worshipful Company of Grocers
Sir Siegmund Warburg's Voluntary
Settlement

PUBLIC FUNDING

Supported by
ARTS COUNCIL ENGLAND

supported by
h&f
putting residents first

If you are interested in supporting the Bush, please visit the 'Support Us' section of www.bushtheatre.co.uk, email development@bushtheatre.co.uk or call 020 8743 3584

BIOGRAPHIES

MATT ANGOVE

Working in theatre since 2004, Matt has worked on a wide variety of projects, including musicals, plays, interactive theatre and dance. Specialising in sound, he has undertaken numerous sound designs as well as No.1 sound operator roles. Sound Design credits include: *Last Seen* (Almeida Theatre, London), *Beyond The Frontline*, *They Only Come At Night: Resurrection* (The Lowry, Salford), *They Only Come At Night: Visions*, *Helium*, *59 Minutes to Save Christmas* (Barbican, London), *They Only Come At Night: Pandemic* (Singapore International Arts Festival) [all for Slung Low], *Lord Of The Flies* (Theatre Royal, Glasgow for Matthew Bourne New Adventures) and *Northern Exposure Season* (West Yorkshire Playhouse, Leeds). Operator Credits include: *Matthew Bourne's Cinderella* (UK Tour) and *Lord of the Flies* (Theatre Royal, Glasgow), *Company* (Sheffield Theatres) and *Backbeat* (Citizen's Theatre, Glasgow).

CLARE DUFFY

Clare recently finished her practice as research PhD at Glasgow University and lives in Edinburgh. She is a co-director of Unlimited Theatre, for whom she has co-written most of the company's work, including recently *The Ethics of Progress*, *The Moon The Moon*, *Mission To Mars* and *The Giant & The Bear*. Clare won a Pearson Award for her first full-length play, *Crossings* in 2003, which was produced, published and toured by Script Cymru in 2005. This led to the commission of *A Good Man* at the West Yorkshire Playhouse and writing for Radio 4 drama. More recently Clare co-wrote *ANA*, a bi-lingual play for Stella Quines and Imago Theatre, with Pierre-Yves Lemieux, which opened in Montreal in November 2011 and toured Scotland in Spring 2012. She's very much looking forward to Edinburgh-based Magnetic North producing *Some Other Stars*, a new play about 'locked-in syndrome', in Spring 2014. Clare is also a member of a new writer-led company Agent 160 and Associate Playwright at the Playwrights' Studio Scotland.

DAVID EDWARDS

David Edwards is a composer and drummer from Bristol. Recording and producing under the name Minotaur Shock, he has recorded and produced four instrumental electronica albums for labels such as 4AD and Melodic. The most recent of which, *Orchard*, was released in 2012 and received some lovely critical acclaim. David has undertaken remixes and collaborations with artists including Bloc Party, Super Furry Animals, Snow Patrol, Gold Panda and Perfume Genius, and has produced music for TV and film production companies and various advertising campaigns. He has collaborated with Unlimited on a number of productions over the last few years (providing original music for *The Moon The Moon*; *Mission To Mars* and *The Giant and the Bear*), which has been great because he loves working with those guys.
www.minotaurshock.com
www.bagatellemusic.co.uk
@minotaurshock

LUCY ELLINSON

Lucy Ellinson's theatre work includes *Trojan Women* (The Gate), *Oh the humanity! and other good intentions* (Northern Stage/Soho Theatre), *Tenet* (Greyscale/The Gate), *A Thousand Shards of Glass* (Jane Packman Co), *Where we meet, Who you are, At Home, Home-made* (Chris Goode), *Speed Death of the Radiant Child* (Chris Goode, The Drum/Theatre Royal Plymouth), *They Only Come at Night, Helium* (Slunglow Theatre, BITE/The Barbican), *3rd Ring Out* (Metis Arts), *Presumption* (Third Angel) and UK premières for *Land Without Words* (Suite 42) and *Monsters* (Christopher Haydon/Arcola Theatre). Lucy is an associate artist with Forest Fringe and Third Angel; her solo work includes *When I Was Old, When I Get Young* (RSC/Pilot Night), *One Minute Manifesto* (Forest Fringe, BAC) and *#TORYCORE* (Forest Fringe/The Gate/The Arches Brick Award 2012). She has previously worked with Clare Duffy on *Local Reality Expo* and *The Fall*, and with Unlimited on their shows *The Swing Left, Tangle* and *Mission To Mars*.

BRIAN FERGUSON

Brian Ferguson's theatre work includes; Richard *III/Aztec Trilogy, Dunsinane, Shakespeare in a Suitcase* (RSC), *Earthquakes in London* (National Theatre), *Dark Things, Fall* (Traverse, Edinburgh), *The Drawer Boy* (Glasgow Tron), *Blackwatch* (National Theatre of Scotland), *Rupture, Snuff, They Make Noises* (The Glasgow Arches), *Particularly in the Heartland* (The TEAM), *Observe the Sons of Ulster Marching Towards the Somme* (The Glasgow Citizens Theatre). For television, his credits include *Field of Blood, The Prayer, River City* and *Taggart*. Brian received Best Actor nominations for his portrayals of Cammy in the National Theatre of Scotland's original production of *Blackwatch* and Danny in the Traverse production of *The Dark Things*. He took part in the original development work on *MONEY the game show* in Scotland in 2011.

RICHARD GODIN

Richard Godin trained at Central School of Speech & Drama. His recent Lighting Design credits are: Michael Clark's *The Barrowlands Project* (Closing of the 2012 Cultural Olympia, Glasgow), *DV8 – Can We Talk About This?*, Co-Design (Slovenia, Korea, Taiwan), *No Sweat* (The Generating Company, Sarlet, France & Touring), *A Christmas Carol, Diary of a Nobody, Travels With My Aunt* (Royal Theatre, Northampton), *Top Girls, Assumption, The Lover, Under Milk Wood* (The Mercury Theatre, Colchester), *Twelfth Night, From a Jack to a King, A Slice of Saturday Night* (The Queens Theatre, Hornchurch), *Speakout* (English Touring Opera), *Henry V* (Chichester Festival Theatre), *The Diva in Me* (Brighton Pavilion, Greenwich Theatre, Devonshire Park), *The Other Road* (National Theatre, Watch This Space), *The Servant to Two Masters* (Komedia), *Uncle Montagues Stories From the Shadows* (Old Vic Tunnels). Richard has toured extensively internationally with DV8 Physical Theatre (*Can We Talk About This? & To Be Straight With You*) and Complicite (*The Master and Margarita & A Disappearing Number*). Please visit www.richardgodin.co.uk

RHYS JARMAN

Rhys was one of the winners of the 2007 Linbury Biennial Prize, for his designs of Varjak Paw for the Opera Group. For Unlimited Theatre, Rhys has previously designed *The Moon The Moon* and *Mission To Mars*. Recent work for opera includes *Orlando Generoso* at The Barber Institute of Fine Arts, *Cycle Song*, an opera for the 2012 Cultural Olympiad, *Hot House* (Royal Opera House Education, main stage) and *The Barber of Seville* (ETO) Other operas include *Ludd and Isis* (Royal Opera House Education), *The Sleeper* (WNO MAX) and *The Bear* (with the Jette Parker Young Artists Programme in the Linbury Studio Theatre). Recent theatre projects include *The Secret Garden* (Halifax Square Chapel), *Missing* and *Number 5* (Gecko Theatre), *Diary of a Nobody* (Royal and Derngate Theatre), *Romeo and Juliet* (Night Light Theatre), *Time for the Good-looking Boy* with Iqbal Khan and *The Country* with Simon Godwin. Designs for television include set designs for series 5 of *Dr Who* and *Young, Autistic and Stagestruck*, for Channel 4.

SIMON PERKINS

Simon Perkins read Drama at The University of Hull. He previously worked at the Bush as Technical Stage Manager in 2012 on *Radar Festival*. He is a regular collaborator with RashDash as Lighting Designer and Production Manager, recently working on *The Honeymoon*, *Another Someone* (Fringe First/National Tour), *Scary Gorgeous* (Fringe First, two MTM Awards/National Tour), *Ugly Sisters* (three MTM Award Nominations/shortlisted for a Total Theatre Award). In 2011 Simon joined 2011 Foster's comedy award-winner Adam Riches as his Technical Stage Manager on the *Bring Me the Head of Adam Riches* (Edinburgh Fosters Comedy Award 2011, North American Tour/ Soho Theatre). Simon's other credits include Production Manager and Lighting Designer on NiE's *Hansel & Gretel* (The Junction, Cambridge), Production Manager on Gonzo Moose's *I'm An Aristocrat Get Me Out of Here!* (National Tour), *What the Dickens?* (Pegasus Theatre, Oxford/National Tour), Deafinitely Theatre Company's

Tanika's Journey (Southwark Playhouse/nominated for Off West End Award Best Set). He also was the Lighting Designer and Technical Stage Manager on Deafinitely's *Beauty Manifesto* (NT Connections/Soho Theatre), *Boy and the Statue* (Tricycle Theatre/Tour), *Gold Dust* (National Tour/Soho Theatre), *The Ritual* (National Tour), *Love's Labour's Lost* (The Globe Theatre/National Tour).

HANNAH PARTINGTON

Hannah is currently in her final year at the Royal Academy of Dramatic Arts, studying Technical Theatre and Stage Management. Credits during training includes: *The Acid Test*, *Blue Stockings*, *Bloody Poetry*, *Shakespeare School Tours*, *Cymbeline*, *The Brothers Karamazov*, *Saturday Night*, *Dealing With Clair* and *The Mysteries*. Prior to starting at RADA, Hannah has worked in various capacities at the National Theatre, Southbank Centre, The Broadway Theatre Catford, Greenwich Theatre and The Albany.

WRITER'S NOTE

MONEY *the game show* really began in 2010 when I wrote and directed a short play about a couple who put a pound 'in the pot' for every day they were together. The play follows 'Small', who decides to run away with her half: 500 pound coins.

The play was for a small audience sat around a long dining table covered with 500 real pound coins. I could see using 'real' pound coins as part of a fictional drama was exciting and even hypnotizing for an audience. Of course it is intriguing to play with money, because it runs through our lives in such intimate and profound ways. It connects with almost everything we want and need to live. But it seemed to me that because the coins were in the make-believe space of a theatre their power, as icons, even perhaps fetishes, became clearer.

This led me to think about how, when we spend money in everyday life, we use the same processes of imagination and belief (and suspension of disbelief) as we do in theatre. Money is quite like theatre, perhaps because it actually *is* a kind of performance. Perhaps theatre is a particularly good place to think about money because we find it so hard to see how performative it is in everyday life and of course what kinds of performances it demands of us. Cash, credit cards, debt, whatever form money takes it's always a representation of something else, sometimes it's another thing like gold, but probably more often it's an intangible value like trust or belief in someone or something. I discovered that by putting actual money on stage the performance of money became more visible and more volatile.

I took this quite abstract thinking to The Arches and their Platform 18 New Directors' Award in 2011 and persuaded them I could tell a story about Money in response to the economic crisis. I said I wanted to put the whole of the award, £6,000, on stage in order to ask: What is the value of money? Platform 18 is a great award. It offered me 6,000 pounds to try out a new idea for an interactive show and gave me a huge amount of support

in taking risks, not least encouraging an audience to throw actual money around. This particular sum of money also helped me to focus on the core questions of the show. For example, the ITC/Equity minimum wage for an actor is £400 per week. Just to employ two actors for a standard 4 weeks rehearsal and 2 weeks of performance would use up almost the entire budget.

These local economic facts starkly contrasted to the emerging national and international economic situations. In 2011 public budgets were beginning to be cut as a direct consequence of the trillions that were being pumped into the global economy, simply so it wouldn't collapse. In the UK we were just beginning to glimmer what that idea 'austerity' would mean on the streets and in our homes. In the Eurozone, where the bailouts of banks were being followed by bailouts of nation states, the future of the Euro itself was beginning to be questioned.

In the summer of 2012, Unlimited Theatre started talking to Madani Younis, Artistic Director at The Bush, about co-producing the full version of *MONEY the game show*. I began to think about the impacts of having a production budget increase approximately to the power of 10. £60,000 isn't a huge budget, but it still means that 2 actors, 1 designer, 1 lighting designer, 1 composer, 1 sound designer, 1 stage manager, 1 production manager, 1 bouncer, and 1 writer/director get paid properly. That's at least 10 people. There are also many other people who gain from this investment: skilled people made the set and props; balloon manufacturers and toyshops have boomed thanks to this show; and Oberon Books will hopefully sell lots of these books you are reading now. As the show runs and tours it will also generate business: people will buy drinks; restaurants will sell pre- and post-theatre dinners; taxis will be hailed.

However, I didn't spend much time thinking about how much the show would return to the economy. I was thinking instead about how much more fun it would be to play with 10,000 pound coins on stage. How much more amazing the actors would look in costumes that weren't borrowed off someone's mate. 'There can be spinning

lights and musical stings!' I thought. (It turns out that actually there *can't* be spinning lights – to spin a light would wipe out the entire set budget.) But I was most excited about how many more people might come and take part in the show.

I extensively rewrote the script in the winter of 2012. As part of that process I interviewed a number of people who work in financial services or study economics. I was particularly struck when a capital investment banker talked about the current economic situation being an opportunity to re-evaluate 'the fundamentals'. 'What is the value of money?' was my first and quite fundamental question. Now that I have had the chance to revisit it, with a bigger team of collaborators, with my partners at The Bush and Unlimited, I can see that this show also hopes to ask: 'What do we want *and need* money to be?'

MONEY the game show was still in development as this script went to print. As a result, the printed script may differ from the performed version.

Clare Duffy

MONEY the game show

OBERON BOOKS
LONDON

WWW.OBERONBOOKS.COM

First published in 2013 by Oberon Books Ltd
521 Caledonian Road, London N7 9RH
Tel: +44 (0) 20 7607 3637 / Fax: +44 (0) 20 7607 3629
e-mail: info@oberonbooks.com
www.oberonbooks.com

A catalogue record for this book is available from the British
Library.

PB ISBN: 978-1-84943-505-5
E ISBN: 978-1-84943-650-2

Cover design by Analogue

Printed, bound and converted
by CPI Group (UK) Ltd, Croydon, CR0 4YY.

Visit www.oberonbooks.com to read more about all our books
and to buy them. You will also find features, author interviews and
news of any author events, and you can sign up for e-newsletters
so that you're always first to hear about our new releases.

Characters

QUEENIE
ex-hedge fund manager. Female

CASINO
ex-hedge fund manager. Male

(Stage directions in italics)
and
(text that might not be spoken in plain brackets)

/ indicates that the next line continues as the
current one ends

The titles for each scene are displayed at the
beginning of each scene.

1.

WELCOME

QUEENIE and CASINO meet the audience in the front of house. The title here might be displayed as a simple poster/sign.

QUEENIE:	Hello. Welcome to our show. I'm Queenie and this is Casino.
CASINO:	We're hedge fund managers.
QUEENIE:	We *were* hedge fund managers. After the financial crisis in 2008 we decided to become performance artists!
CASINO:	In 2010 we applied to The Arches,
QUEENIE:	Which is a theatre in Glasgow,
CASINO:	For their new directors' award.
QUEENIE:	We won.
CASINO:	We love to win.
QUEENIE:	We won…6000 whole pounds! To make a show.
CASINO:	In 2011 we put all that money on stage in £1 coins.
	And did what we do best. We played Money.
QUEENIE:	It's a game.
CASINO:	And a show.
QUEENIE:	You may have noticed that it's now 2013.

CASINO:	It's *(date)*. And we're now here in *(place)*.
QUEENIE:	Thanks to a friendly take-over by joint investors Unlimited Theatre and The Bush.
CASINO:	We've got a bigger and therefore better principle on stage. Yes. Ladies and Gentlemen 66.3 recurring% more…we've got 10,000 pounds to play!
QUEENIE:	Woooo!
CASINO:	*(To her.)* Are you going to do that a lot?
QUEENIE:	No. Just a one-time thing. Breaks the ice.
CASINO:	OK. This is our play on the value of money. Based on our lives.
QUEENIE:	Which for legal reasons are completely fictionalised.
CASINO:	If you have an even number on your ticket you're my clients.
QUEENIE:	And if you're odd you're in my team. Come on.
BOTH:	Let's make money!

2.

£10,000

The title sign is flipped over so that we see the title for the next section.

We move at speed from front of house, outside the theatre, to enter the auditorium through back stage areas, pausing to gamble (heads and tails) on the way.

This is a pound coin. This is a Scottish one. Look. Inscribed is the great Scottish motto. *Nemo me impune lacassit* which means 'no one provokes me with immunity' or 'Are you messing with me?!!!' That's brilliant isn't it?!

Heads or tails? Go on. If you win you can keep it. You've got nothing to lose. Heads or tails?

(Audience response.)

With this coin you can buy something that costs £1. Like…2 pints of milk. Perhaps tomorrow it'll be 1.5 pints of milk. But I wouldn't put any money on it. Course not. Prices don't go up that quick do they? Not here. Not in London. *(Or the name of the place the show is in.)* This currency was created in 1971, £1 then would buy you £11 pounds' worth of goods and services today. So having one of these *(Shows the pound coin.)* now, would be more or less, like having one of these *(Shows a ten pound note.)* then.

What else can you buy with a £1? 1.6 Curlywurlies? Three little, plastic airport security bags, for your gels and liquids? Half a *Big Issue*? Here and now, London 2013... food prices *are* going up, but in Argentina in 1989 inflation was so rampant they said you were best to buy your meal before you ate it, because it would cost twice as much by the time you finished it.

Being a hedge fund manager is all about being really really good at gambling. I love gambling because it reminds me that money isn't as 'real' as it seems. Money is a game. A great game! Intimately, heart poundingly, hand in hand with life and death, skin and bone, war and peace. But still a game!

Flip coin...win/lose...pay out. Enjoy it.

Come on!

Lead the audience on again, then stop and lean against the wall as if to smell the air.

Look! *(Takes another pound coin out of pocket.)* On *this* coin it is written: *Decus et Tutamen.* It's the motto for the Essex artillery regiment. Latin, from a poem about a Greek wanderer and it describes a prize of armour. Usual translation, 'shield and protection', which seems a bit tautological to me, I mean, a shield *is* a protection, right? But it can also mean 'an *ornament* and a safeguard', which is a much better question, isn't it? I mean...is this coin something to look at or something that will keep you safe?

Looking at it, it obviously isn't *real* gold. It doesn't even *represent* real gold. At one time it could represent real gold, safe, somewhere

else…like in the vaults of the Bank of England, or Fort Knox. This pound doesn't represent any essential or finite value, but it feels right it's the colour of gold doesn't it it? *(Back to audience member who won/didn't win the pound.)*

Nixon removed the gold standard from the dollar in 1971 arguably to pay for the Vietnam War, thus breaking the Second World War 'Bretton Woods' agreement. The price of US and UK gold reserves soared. And the dollar devalued. Since '71 the currency of currency, its flow and eddy has been much less steady, more exciting, more vulnerable to storms and undertows, no real-gold anchor no more…which gives us much more opportunity for profit.

(To audience member.) Do you want to have another bet? Go on!

Flip the coin. Win/lose…pay, enjoy.

Come on!

Move at fast pace further on. Stop suddenly.

A coin is an icon. A symbolic place where meanings and worlds meet…exchange. A place between price and value. Between citizen and nation, between belief and the material world…that is…between what you think and what you touch. You could say *(Finds self funny.)* it's two sides of the same coin. Well. It actually doesn't matter whether it's written on a piece of paper, or a clay brick, in binary code, lights on a screen or blood. Money is faith, belief…what you credit…written on something. On a dollar bill it says 'In God We Trust'. But we're

going to play heretic in the church of money. Because that's what ex-hedge fund managers should do. We're maverick. We're free. And we're here to save the world!

Nearly there! Now. Our world of finance is full of jargon. It's designed to make you feel outside. Not part of the club. Don't let it. The principles aren't hard. Hedge fund managers look after money from private investors. We bet on the value of things. Betting value will rise is called a long bet and betting it will go down is called a short bet. Some people have a problem with betting short. They think we're profiting from the pain of others. But if we're betting something's going down, we're doing it because we *really* think it's going down. We're the canaries in the mine. The bulldog at the gate. We're the early warning system. We risk our own money and we are accountable to you, our clients.

Just before going in.

We're going to be playing with 10,000 pounds in actual pound coins, and you should be clear, you can't take any of them home with you. But there will be consequences if we lose.

I'll kill myself. Seriously. I will.

So, go team!

Hand on door.

Now have any of you got an unlikely special talent you'd be willing to bet no one in the other team has too? Standing on your head? Sing the theme tune to *The Fresh Prince of Bel Air*? *(Find a thing to do.)*

How you feeling? *(Listen to actual responses, read their body language, reassure them that it's going to be nice.)* Confidence is everything. Don't worry you're on my side and I'm the best.

Both teams enter the performance space from different entrances. The space should feel like a surreal magical grotto. The two teams sit in separate areas. There is a long red carpet. At one end there is a pile of 10,000 one pound coins, at the other end are two old suitcases from different times. 'Optimistic Voices' music from The Wizard of Oz is playing. There is a spotlight on the coins, soap bubbles from a machine are blowing. There are black balloons creating the graphic line of the 2008 US housing market bubble. The audience take their seats on opposite sides to each other. A burly stage manager (Simon) is standing by the money with the bubble machine. There is a live CCTV recording being screened, showing that the audience are being watched.

QUEENIE: Thank you Simon.

CASINO: We'll take it from here.

Simon exits.

CASINO: Hi there Queenie.

QUEENIE: Casino.

CASINO: *(To audience.)* Please take your seats.

CCTV roams through the audience as they sit.

QUEENIE: Check you lot out on the CCTV!

CASINO: Give yourselves a wave!

QUEENIE: Risk takers at the front, those more risk averse to the rear.

Music fades.

3.

I$ IT RE€AL?

The title is projected onto the screens. CASINO and QUEENIE speak to the audience from the far end of the carpet from the money.

QUEENIE: So there it is. 10,000 pounds.

CASINO: Doesn't look much. Does it?

QUEENIE: That's not a bad week of Box Office at The Bush.

CASINO: Our combined fees…after tax…for three months' work.

QUEENIE: At least we don't have to be at our screens at 6 a.m. everyday.

CASINO: It's a car.

QUEENIE: A rubbish car!

CASINO: Two weeks in Geneva.

QUEENIE: A night at the races.

CASINO: Here. Now. It's just our prop.

Bouncer coughs. QUEENIE notes it.

QUEENIE: But not actually ours.

CASINO: Belongs to the show.

QUEENIE: To our investors The Bush and Unlimited.

CASINO: Would one of my team please verify that those 10,000 pound coins are in fact real?

QUEENIE: That's not fair. One of our team has to check too. You?

CASINO: And you for us?

As the audience come on to stage there is theme music or more 'Optimistic Voices' music quietly underscoring.

Great. So go and check that they are actual pounds you can buy things in shops with.

Participants might need a bit of encouragement to touch them, might not. As they are getting up, the bouncer steps forward and makes his/her presence felt.

QUEENIE: I should also introduce you to (Bouncer's name). For the insurance company to let us put this amount of money on stage we had to demonstrate that we were willing to kick the shit out of anyone who tried to nick it. That's what you're here for isn't it (Bouncer's name)?

Bouncer nods.

CASINO: We tried to explain that money was faith, magic, decoration and armour, two sides of a coin, all that. But they just said. Yeah. We need the shit kicker, or the show's not going on.

(To participants encouraging them not to worry about the bouncer.) But don't worry. Fear ye not.

CASINO may add an additional encouragement during QUEENIE's next speech.

QUEENIE: Funny thing is, even though we get people to check to see they're real (yes that's right get

stuck in there) there are always some people who find us at the bar, after the show and say, 'But how did you make *all* that money?' Literally thinking we *made* all those coins out of…I don't know…modelling clay and gold paint? That would be more expensive than buying 10,000 pounds! Unless we found a sweatshop somewhere maybe…

So? Are they real?

PARTICIPANTS: 'Yes'

CASINO: OK. Thank you. *(As the participants walk back and sit.)* Were you tempted?

Lights out suddenly. Music stops. CASINO and QUEENIE talk to Simon who is operating.

QUEENIE Simon. Stop messing about.

Turn the lights back on.

CASINO: I trust my team.

QUEENIE: I trust mine.

CASINO: No one wants to be caught with their hands in the till.

QUEENIE: And we are still being recorded on CCTV. Ooooh!

CASINO: Stop that!

It's a risky little game.

QUEENIE: You love it.

CASINO: So do you.

QUEENIE: How would you characterise your aversion to risk? Bearing in mind that just going outside is risky.

CASINO: And most fatal accidents, murders and nasty
 stuff happens at home.

*Lights back up. A moment to look around. Has anything moved? CCTV
back on and 'looks' at the audience.*

QUEENIE: Risk is a fact of life. My gut tells me when
 and how far to push it.

CASINO: But I prefer to calculate the odds.

*The following 'bets on stupid stuff' change every night, depending on
what responses there have been from the audience on the way to the
performance space.*

QUEENIE: First off. We need to get some cash in our
 funds. *(Producing a colourful kid's plastic
 bucket.)* I bet you a bucket of pounds that no
 one in your team can (walk on their hands)
 for 3 seconds. Where's our champion (hand-
 walker)? Please take to the stage.

Theme music.

CASINO: *(To audience.)* OK. My team. Anyone able to
 (walk on their hands)? You can?! Brilliant.
 (Or establish that no one is taking the challenge.)

 We'll be taking that bet Queenie and you are
 going go lose! *(Or.)* No. No one here can. But
 you can't have that bucket until you do it.

QUEENIE: *(To audience member.)* What's your name?
 Hello there (name). Are you ready?

Player gets ready. Lights spin/flash.

 When I say go…go!

Game Sting.

 Go.

*The team member does their special talent (or not) and all the money
that was bet is poured into the winning side's suitcase.*

CASINO:	Now it's our go. We've got a great one. I bet that no one in your team is a (real hedge fund manager) and can prove it.
QUEENIE:	*(To audience.)* OK. My team. Anyone (a real hedge fund manager)? You are?! Brilliant. *(Or establish that no one is taking the challenge.)*
CASINO:	Can I have our champion on stage please?

Theme music as player takes to the stage.

CASINO:	Ready?

Lights flash/spin.

OK. When I say 'go'. You go. Right?

Game Sting.

Go.

QUEENIE:	Brilliant. Well done. So. Who's out in front?

They agree who is winning so far, or if it is a draw.

CASINO:	All or nothing…for you to do the rest of the show naked.
QUEENIE:	Alright. I'll take that bet, but not for the money, for your heart, and not your love… your actual heart.
CASINO:	Don't be ridiculous.
QUEENIE:	Why?
CASINO:	Because there are some things…some things don't have a price for fuck's sake.
QUEENIE:	Perhaps they shouldn't have a price. But sometimes you've got to get skin in the game.
CASINO:	Time for a better game then.
BOTH:	Let's make money!

4.

FOREVER BLOWING BUBBLES

Title up on screens. CCTV.

CASINO: *(To team.)* First of all we need to get some money into our fund. That case there is *our* fund. *(Points at Casino's suitcase.)*

QUEENIE: *(To team.)* We need to get as much of that *(Points at money.)* into our fund as possible.

CASINO: *(To team.)* And we're going to get more. Right? Oh yeah!

 (To QUEENIE.) Heads or tails?

QUEENIE calls and whoever wins then explains:

WINNER: I won. I'm going first. I'm going to blow a bubble. While I'm blowing it we can put money in our fund. That case, there, right?

 While I'm blowing the bubble there will be music. During that time you can put money in the fund. But only using your hands. If you are moving when the bubble bursts, and the music stops, you have to put the coins in your hands back in the pile. Clear?

LOSER: So you guys, to make sure they don't cheat, if you see the bubble burst, put your hands up

in the air, like this *(Demonstrates putting arms in the air and waving hands.)* ...so that Simon ...Simon *(Wave at him.)* ...turns the music off. That makes you regulators right! This isn't 'light touch' regulation...as we like to say... regulation can be really rewarding!

WINNER: So. We need a player. (A volunteer.) You? Great. *(Gets a player on stage.)* Let's give them a bit of support. Give your champion a cheer! *(Encourage audience to clap/cheer.)*

What's your name? *(Player answers.)* OK. *(Name of player.)*

Are you good to go? *(Reiterate what they are doing if they are not clear.)* Great!

BOTH: Let's play!

Game Sting. Lights. Volunteer gets in place.

WINNER: Are you ready? Steady? Go!

Lights change. Music: Madonna. 'Hung Up'. When the bubble bursts the music stops. Lights spin/flash again with Game Sting.

LOSER: So. Now. We need to beat them. A champion for our team please!

Get player onto the stage. The audience will usually cheer their players now as they come to the stage. But are always encouraged by their hedge fund manager.

LOSER: That's it. You know it. They're your hero! Same deal. The music plays. You get a shit load of money in our fund. Got it?

Game Sting. Lights spin/flash.

LOSER: Ready? Steady? Go!

Music plays. Madonna. 'Hung Up'. The audience are encouraged to cheer. The bubble bursts. The music stops. The lights spin with Game Sting.

QUEENIE: That was Madonna, No. 1 in 2005, when money was cheap and we liked to throw it around.

CASINO and QUEENIE note who is winning so far.

CASINO: *(Referring to the money in the 'cases'.)* I'm going to call our fund Casino.

QUEENIE: *(To her team.)* And you're the members of the Queenie fund.

Lights spin/flash. Theme music. CCTV off.

5.

HOW WE MET

Title is projected onto the screens. Lights change to suggest an interior: A casino. There are sounds of coins being dispensed from a slot machine. Briefly the screens show a slow-motion image of coins falling through space.

CASINO: We met in a casino.

QUEENIE: My old haunt. Mayfair.

CASINO: Winter 2005. That's over seven years ago already! /fuck

QUEENIE: /I was slightly over-the-limit.

CASINO mouths 'very' behind her back.

 'Celebrating' my bonus.

CASINO flips a £1000 chip in front of QUEENIE's feet. She puts her foot over it and looks around. Catches CASINO's eye. Looks away.

CASINO: You're standing on my chip.

QUEENIE: Your chip?!

CASINO: Yes.

QUEENIE: If it's yours, why isn't it in your pocket?

CASINO: It fell.

QUEENIE: Shame.

CASINO: You can have it if you want it.

QUEENIE: *(To audience.)* I was bored. Pissed, bored and gutted. My bonus was bullshit…a million is nothing. And I was supposed to make MD that year! Slap in the fucking face! In my old job, the year I'd had, I'd have made 2 million.

 Everyone moans about their bonus. Mandatory ritual. But I'd been Exec Director for two years. It was my time. And there was something else. Had a seriously nasty feeling. My career was built on taking those sorts of feelings seriously. Markets are too vast and complex to analyse everything. Have to trust your instincts. Like riding. As in the hunt. Flow is Queen.

CASINO: I've got lots more.

QUEENIE: Shall we bet it?

CASINO: If you want. It's yours now.

QUEENIE: Don't I know you?

CASINO: Yes.

QUEENIE: Last week. Royal Bank of Scotland…right?

CASINO: An insignificant quant.

QUEENIE: Well. You're doing alright here.

CASINO: Only way of getting any proper dollar.

QUEENIE: How I started too.

CASINO: I know.

QUEENIE: Ooh…really!

CASINO: Risk requires research

QUEENIE: You think?

So, you're putting this £1000 chip on me?

CASINO: Yes.

QUEENIE: That's very cute. What's the stake?

CASINO: I want in. It's my foot in the door.

She picks up the chip and flips it in the air.

QUEENIE: Nice foot.

CASINO: Thanks.

QUEENIE: But I don't need anyone.

CASINO: Ah…no but see you need me. I'm numbers genius with charm. I'm a quant that can sell. In the superposition of the new financial multi-verse…I'm…I'm a quantum threat.

It makes QUEENIE laugh.

QUEENIE: You're just a casino boy.

CASINO: I've got to get out.

QUEENIE: Disappointed with your desk at the new office. Where is it again?

CASINO: Gogarburn. But I'm not/

QUEENIE: Did you meet the Queen when she came?

CASINO: No. Will you shut up and listen?

QUEENIE: Thinking is RBS will break a trillion by assets soon.

CASINO: I think it's going to blow sky high.

QUEENIE: Oh fuck off!

CASINO: I mean 1000s of RBS employees in the streets begging like fucking waifs…like

fucking zombies, because we've all levered up our bonuses to the/ max

QUEENIE: Wasting my time. I like the chip and the chat and the

CASINO: I'm dead-fucking serious.

QUEENIE: Zombies?!

She turns to leave.

CASINO: How robust do you think RBS's capital position really is?

QUEENIE turns back interested.

QUEENIE: Fred's had some shareholder issues. That's not news. But my-god, look what they've done in the last three years.

CASINO: What do you think his next move is? What do you think *he* thinks is the silver bullet?

QUEENIE: What?

CASINO: Credit markets.

QUEENIE: Original!

CASINO: Sub-prime.

QUEENIE: Ha!

CASINO: CDOs of sub-prime American dreams.

QUEENIE rolls her eyes.

CASINO: My thoughts exactly! What a wanker.

QUEENIE: Ha!

CASINO: See. I knew you'd like me.

QUEENIE sips her drink.

CASINO: But you're steering clear of credit.

QUEENIE: How do you/?

CASINO: And they're making you pay for it.

Pause. QUEENIE asks 'how do you know?' with her eyes. CASINO says 'I know.'

CASINO: Just how leveraged do you think RBS is?

QUEENIE asks with her eyes.

CASINO: More than they say.

QUEENIE: Are they are actually *lying* about their capitalisation?

CASINO: I can prove their definition of capital is significantly deficient.

QUEENIE: Ha!

CASINO: You're all good. Right?

QUEENIE: They're not the only ones. We're levered by 25.

CASINO: Which is reasonable.

QUEENIE: Yes. Probably.

CASINO: Imagine borrowing 60 times what you know you can pay back.

QUEENIE: I've been thinking. If US house prices fall /

CASINO: Every over-leveraged bank holding sub-prime and toxic credit could fail.

QUEENIE: Do you have any actual data? Any idea when sub-prime goes to zero?

CASINO: Zero? Really? Yes. No. I could have. I don't have the resources to do it. But I could do it if there was some room in your back office.

QUEENIE: Maybe we do have a temporary corner.

CASINO: That the royal 'we'.

QUEENIE: Might be. Give me that research, water tight, in a month and I'll speak to my boss about you.

CASINO: You want to play that chip now 'Queenie'?

QUEENIE: How's your blackjack 'Casino Boy'?

CASINO: Pretty fucking great actually.

Blackout. Soft version of Game Sting. Spotlight up on CASINO.

(To audience.) I wasn't born into money. I can see it for what it is because I was never embedded. Money was never invisibly 'just there' for me.

Where I come from the value of a loan default could be your mum...or your little brother, not their actual lives maybe, but... the price of a week's housing benefit might be valued with a bone, a rape, perhaps a lifelong dance with the devil. Loan sharks are never cynical, they know the value of everything and price accordingly. But where I come from...if you're hungry...there isn't anywhere else to go. Everyone else has the banking system.

QUEENIE: *(Half-lit.)* Had the banking system.

CASINO: When I was a kid I thought they were called sharks because of the way they moved. My mum had an arrangement with 'Mr Smith'. 'Mr Smith' didn't look that sharp, but he glided through the estate like it wasn't really there, like his feet left no print. Dull-eyed and damp-browed, his world was liquidity itself. Impossible to get hold of. Fatal to pay-

off. I had to move everyone out of town to escape him for good.

Sharks are much more visible since 2008. Don't you think? There they are, sat on their stools, behind their counters. A 1000 new 'Mr and Mrs Smiths' on the high street offering their pay-day loans. Legal sharks shoring up huge profit because the demand for credit didn't go away just because the banks won't lend.

6.

RISK FOR BUBBLES

Title is displayed on the screens. Lights spin/flash. Theme music. Game Sting. CCTV on screens. QUEENIE tosses a coin.

QUEENIE: Heads or tails?

CASINO calls.

QUEENIE: One more chance to get money into each of our funds. We're going to introduce a bit more risk and therefore potential reward into the game. This time if you're moving with money when the bubble bursts and the music stops then you have to put it into the other team's fund. Ooooh!

CASINO: *(Trying to ignore the irritating oooh!)* But now you can also use these *(Hold up buckets and spades.)* and even the golden shovel to move the coins.

WINNER: So. We won the toss. We get to go first. Can I have a player please? Don't be shy, even if you're at the back. It's lovely up here in the lights!

Get a player onto stage. Encourage a round of applause. Theme music to cover the journey.

WINNER: Your name? Excellent. Are you clear? You use the buckets and spades to put money into

our fund. That one. *(Points.)* But if you're running when the music stops it has to go into their fund. Right? Great! Take your position.

Player gets ready. Lights spin/flash. Game Sting. Quiet.

BOTH: Let's play!

 Ready. Steady. Go!

Music Scissor Sisters: 'I Don't Feel Like Dancin'' The bubble bursts. Music stops.

WINNER: Well done (name of player)!!! You are the bomb!

LOSER: Right you lot this is our last chance to get as much of that *(Points at coins.)* into our fund! Who's got what it takes? Who's fast on their feet? Deft with a shovel? You sir/madam?! Excellent. What's your name?

 Take your position.

Lights. Game Sting. Quiet.

LOSER: Ready? Steady? Go!

Music Scissor Sisters: 'I Don't Feel Like Dancin''. Game ends. Lights spin/flash. Game Sting.

LOSER: Well done (name of player)!

CASINO and QUEENIE assess who has the most money so far.

WINNER: We've got so much more than you!

LOSER: So. We've got so much more skill than *you*! We're still going to win. No way am I killing myself tonight.

CASINO: That was the Scissor Sisters...2006.

7.

WOULD YOU RISK IT ALL?

Lights spin/flash. Soft Game Sting. Scene title is projected onto the screens.

CASINO: December 2006. I not only proved the US housing market was a bubble but that when it burst it *could* take everything down with it.

QUEENIE: *(To CASINO.)* You know…*I* really know what money is. One of *my* ancestors was one of the traders who loaned 1.2 million to William III, in 1694, for his war in France. That loan launched the Bank of England and first genuine paper money! Oh. Yes.

Spotlight on QUEENIE.

(To audience.) My lovely grandfather was a Wall Street man. Fell foul of the crash, 1929. Luckily he met my grandmother, who'd just fled Germany. She saved him from the Great Depression. He always said. But his brother, and partner, went to the Waldorf Astoria one evening in October, ordered two whiskey sours then shot himself in the street. I find myself often thinking about it. I wonder, why like that? In public. No note. What does that mean?

Obviously Daddy never knew his uncle, but Grandpups talked about him a lot. Especially when he was dying. My father was an old-fashioned conservative banker. Boring. Steady. 'Borrow low, lend higher, grow at a steady rate'. I wish I were more like him sometimes.

He was killed in the second tower, 2001. And Mummy's just not been the same since.

…

My hero is George Soros. The hedge fund managers' hedge fund manager. I was 17 when he broke the Bank of England. Imagine having the balls to short the first ever, independent national bank. When he goes to Harvard the students chant his name. Soros: The King. His money, his philanthropy, makes the world a better place.

If I can make enough money, then I can change the world.

Lights change: interior, office space.

CASINO: Also…2006, my wife and I had a baby. Queenie, look.

CASINO shows the audience a photo of a very ugly but still real baby. It flashes up on the screen. CASINO hands QUEENIE a document with a graph on the front page.

QUEENIE: *(Dismissive. Looking through the research.)* She's cute.

CASINO: She's adorable!!!

QUEENIE: This is very convincing.

The graph of the US housing market bubble 1880–2008 is projected onto the screens. Lights on the black balloons.

QUEENIE: Terrifying, but convincing. It's really going to happen isn't it…but when?

CASINO: Isn't she though?

QUEENIE: Yes, yes. Great. Two years. Can't be much later than 2008.

CASINO: We're friends aren't we?

QUEENIE: No.

CASINO: But you trust me?

QUEENIE: Why?

CASINO: What are you going to do with this? *(The research.)*

QUEENIE: I'm going to take it to boss.

CASINO: Are you mad!

QUEENIE: Easy, Casino boy.

CASINO: This is it. We should do this now.

QUEENIE: I'm not going to just /

CASINO: This could be the trade of a lifetime.

QUEENIE: No. We're much more seriously exposed, than I thought.

CASINO: Listen to me.

 Fuck them.

QUEENIE: I'm sorry?!

CASINO: We've talked about this.

QUEENIE: I need this job.

CASINO: If we make this trade ourselves, we'll never have to work again.

QUEENIE: I've just bought a house.

CASINO: Pussy.

QUEENIE: Fuck you.

 …

 We'd never get enough money in time.

CASINO: They'll be queuing up when they see my
 research.

QUEENIE: No. Can't do it.

CASINO: Cos you're a pussy. You owe these wankers
 fuck-all!

QUEENIE: I've got my mum to think of.

CASINO: She'll be glad when you've made your first
 billion.

QUEENIE: It's so easy to push for something when it's
 just not your choice, not your responsibility.

CASINO: You're not usually so coy about pulling the
 trigger.

QUEENIE: Ever think it's strange how much traders talk
 the hunt? Making a killing, eating what you
 kill, pulling triggers, bulls and bears.

CASINO: Because it's exciting!

QUEENIE: What if there's ever real blood on the floor?

CASINO: I'm game.

QUEENIE: Just how far would you go?

CASINO: All the way.

QUEENIE: What about the bundle of joy?

CASINO: It's for her future.

QUEENIE: Do you believe that?

CASINO: There's no risk. Look at the research.

QUEENIE: Anything can happen. Anything could
 happen that changes everything. China has
 democratic elections. Solar wind harnessed
 for free green /energy. Oil discovered in
 Sidcup. Fracking in Paris.

CASINO: /You're a pussy and you know it.

QUEENIE: You've just found a game and you want to
 play it. That's all.

CASINO: And you don't?!!!

 I know you. You're just like me.

QUEENIE: *(Knows he is right and completely wants to.)* No.
 I can't take that risk right now. Not with my
 mother the way she is.

CASINO: OK. Fine. Take it to Boss. He's not going to
 believe you anyway. In fact I bet you our
 fund's first million you're packing up your
 espresso machine before lunch.

QUEENIE leaves. CASINO shouts after her.

CASINO: You're just making it harder for us. We
 should be starting this on the QT now. Not
 fucking telling folk about it…Queenie!?
 Queenie!

 You're just going to get sacked.

*Lights change. An interior: high up, full of sunlight. Abstract images of
flight on the screen. Background noises drop away. It is quiet. QUEENIE
has the document in her hands with CASINO's graph on it.*

QUEENIE: *(To audience.)* I'm on the tenth floor waiting
 for Boss.

 It's so quiet in here. It's so painfully perfect
 in here. The morning sun fills his office.

Out the window I can see the white Royal Naval College and Queen's House, sharp against Greenwich Park and the grey Thames. Pigeons fly past the window, their undercarriages flash gold light as they turn. It's a windy day and the clouds roll past against the perfect blue. I tap my heels on the hard wood floor. There's a Tracey Emin self-portrait behind his desk. She's bending over. Her arsehole seems to follow me round the room. Seems to wink at me from its dark socket.

Boss comes in. He says.

CASINO as Boss.

BOSS: So what the fuck do you want?

QUEENIE: 'Nothing.' I say, my heel wanting to tap. But I hold it down.

BOSS: You seemed a bit fucking determined to see me.

QUEENIE: I don't like his office. I don't like the view. Especially on perfect bright days like today. Planes are coming into land at City Airport. Flashing the same gold light the pigeons do as they turn.

 (To Boss.) I have some concerns about

BOSS: Don't tell me.

QUEENIE: At least it's only the tenth floor.

BOSS: I know what you're going to say, you've said it enough times /

QUEENIE: I've got some /

 (To audience.) I offer him the research but he waves it away /

BOSS: It's your lucky day. I'm sending you upstairs.

QUEENIE: Upstairs?

BOSS: Yes. I think Boss needs to hear your concerns.

QUEENIE: Who?

BOSS: My boss.

QUEENIE: Your boss.

BOSS: That's it. Go and speak to Richard. I've been thinking about that move up you're looking to make. You've been bitching about it for the past twelve months. Impress Richard and we'll see what happens next.

QUEENIE: Richard?

BOSS: Yes. You know. Big guy. Smokes a cigar. Swears a lot. Richard. Richard wants to meet you. He's heard a lot about you.

QUEENIE: Now?

BOSS: Fuck yes. No time like the present. He's waiting.

QUEENIE: *(In spotlight.)* I get out of there PDFQ, heart pounding, shallow breath. Back in the windowless corridor and the soft brown light to comfort me I go to the lift and press the button for up.

8.

GOING LONG

Lights spin/flash. Game Sting: 'Up'. Lights change to the 'game' state. CCTV.

CASINO: *(Two balloons in his hand.)* Heads or tails?

Depending on who wins, one picks a large balloon from the two in CASINO's hands.

CASINO: Now we've got money into our funds, we're going to bet with it. First we're going to bet 'long'. We're going to take 'a long position'. Betting that value will rise.

 So. I bet we can blow this balloon bigger than you can blow your balloon in 30 seconds!

QUEENIE: You're so on.

CASINO: We need two players. One from each team. We're looking to bet on value rising here. So we need a big healthy pair of lungs. Courage in the face of a nearly burst skin. And general attractiveness never hurts.

CASINO and QUEENIE encourage players to the stage.

BOTH: Excellent. Perfect.

CASINO: So, how much do you want to bet?

Negotiate with teams how much they want to bet. Has to be even. If your team is the biggest by the time the music stops you get all the money.

Lights. Game Sting: 'Up'.

BOTH: Ready? Steady? Go!

Music: 'Crazy' by Gnarls Barkley. Teams play the game. The audience are encouraged to cheer. Music stops after 30 seconds. One side wins. Lights. Game Sting: 'Down'.

QUEENIE: More from the hits of 2006. 'Crazy', Gnarls Barkley. Just great!

Players go back to their seats and CASINO and QUEENIE tip the money into the winning suitcase. The Loser shows their disappointment and the winner shows off a bit.

9.

I QUIT

The title is projected onto the screens.

CASINO: *(To audience.)* Queenie used to run a prime broking account, in a multinational bank of securities, investment and retail. The whole thing was massive. 'Titanic.' The next boss up liked to say.

Lights spin/flash. Soft Game Sting: 'Down'. CASINO plays the Boss's Boss. New lighting state suggests an office, full of light. On the screens: Planet Earth.

QUEENIE: I'm now on the 20th floor. See as far as Kent. I don't look out. Put back to window.

BOSS: *(To audience.)* We've grown our firm so big, it can be seen from fucking space.

QUEENIE: Only halfway up. Scared. Dead scared. Thing is when I'm scared I might have a tendency to come over as a bit over-confident, some have even said I might seem a bit *aggressive*.

The chart is projected on the screens. Boss sits.

QUEENIE: *(To Boss.)* You've got to take this seriously. Sir!

BOSS: Dick. Please.

QUEENIE: These numbers keep me up nights. The more I think about it, the more terrifying it is. Just try to imagine. For one moment.

Property prices stop rising. Property flatlines. Houses fall. There are already strong indicators/ look

He laughs.

BOSS: No. I'm sorry.

He continues to laugh at her. She speaks over the top of him.

QUEENIE: We're so heavily into the US sub-prime market, we've got to short it. We've got no idea what that real estate is actually worth.

BOSS: We buy AAA. That's as good as a US bond.

QUEENIE: The credit ratings are wrong. Have you ever looked at one of these contracts? I don't know how anyone can read them, detail and the jargon! We don't even know where our assets actually are. They could be selling loans to the tramps on the street for all we know.

BOSS: So. Even tramps can re-finance in this market, love. Personally I'm bullish on cardboard.

Laughs at self.

QUEENIE: Richard.

BOSS: Please. Call me Dick.

QUEENIE: They're called ninja loans because they're sold to people with no income and no job.

It's not funny. Ninjas kill by stealth. Sneak up on you. We're going to get killed if we don't do something.

BOSS: You want to be a bear? A sulky-walky grrrowly-wouwly bear?

QUEENIE: Yes. I am *very* pessimistic about the future of the US housing market.

BOSS: *(Stops laughing.)* I don't like bears. I like bulls. I like positivity.

QUEENIE: Boss.

BOSS: Are you brain dead? Are you actually in a coma? Do you want me to wheel your bony cold corpse out the back? Dump you in the skips, down tart's alley…for fuck's sake. No one is defaulting.

QUEENIE: You don't know that. This research shows that / in San Jose

BOSS: /No one knows because it doesn't matter. San Jose! House prices go up. Always have. Always will. Lehman Brothers have just announced they're up 44.1%.

QUEENIE: What if they're lying?

BOSS: *(Starts laughing again at how ridiculous she is being.)* Lying! That's a good one. They can't all be lying. The rating agencies? Fanny Mae? That's like saying the Fed is lying. The Bank of England. Are you a communist?!

QUEENIE: Or are just too god damn stupid /and greedy to understand their own business, or what the consequences could be?

BOSS: /Or perhaps you think I'm lying. You think I'm a big fat liar?!

QUEENIE: *(Aside.)* I know he is. I set up the off-book account in the Cayman Islands. There's SPVs in Ghana, Belize and Swizerland.

'Special Purpose Vehicles' isn't *always* code for hiding debts. It's a totally legitimate way of minimizing risk. *(Back to Boss.)* Bit of a problem when you don't actually tell the shareholders about them though. Don't you think?

BOSS: When is a lie not a lie? /When it is absolutely legal.

QUEENIE: All I'm saying is I've got guts on this. I'm good at my job. I love my job. I want to keep doing my job. Let's get some insurance.

BOSS: How are you going to bet against the sub-prime market? You can't short a house.

QUEENIE: There is a way. Credit Default Swaps. You know how they work?

BOSS: Yeah. So?

QUEENIE: If this trade plays, it will play in less than two years. Look. It works like laying down money on a number in roulette. The most you can lose are the chips you put on the table, but if we win you get 30, 40, even 50 times your money. That means five million could churn a quarter of a billion. We can buy the risk of default on the really risky bundles of debt, BBB stuff, for a song. We've got to do this. We could make a fortune here. We could make out like bandits! If we were a hedge fund this would be a no-fucking-brainer Dick!

BOSS: *(Laughing.)* Are you high?

QUEENIE points to the peak of the diagram of the housing market bubble.

QUEENIE: It's a bubble! House prices would need to fall by 40% to go back to the levels they were steady at for 25 years.

BOSS: You have two minutes.

Boss makes it clear that she is boring him.

QUEENIE: *(To audience.)* They could call sub-prime mortgages what they are…pieces of shit. They were literally sold door to door to folk who've got nothing and signed on the bonnets of Hire Purchase cars.

There was a time in the mists of the late '90s when everyone knew that 'sub-prime' was just a euphemism for crap. And then as more and more were sold and everyone started to make lots of money, everyone just forgot, or pretended to forget or never knew or bothered to find out.

He *(Boss.)* doesn't know what any of the jargon means. Not really. CDS, CDOs, squared and cubed, ABX index. We take the ratings agencies' AAA almost as if it means 'no risk'. But I don't know how they assessed these products. We've got no idea what the real risks are. Neither does the Prime Minister or head of the Federal Bank. No one does. For some reason no one is asking.

Your risk management is for shit. Our assets could go to zero.

BOSS: But they won't.

QUEENIE: But they could.

BOSS: *(Serious rage.)* I should reach down your throat and pull out your beating heart for your lack of fucking loyalty.

(Quieter.) Let's suppose it *is* a bubble, if I let you short the market…your betting could *make* it burst.

She turns.

That's reflexivity isn't it? That's the 'quantum' effect right? Looking at it, being in it, changes it? Right?

Oh yes. I read my Soros too.

Your fucking loyalty to your profession should dictate that you refuse to try and crash the confidence of the market in our assets.

QUEENIE: I didn't overprice these houses. I didn't lie about them or offer 100% loans with cashback to people who don't have any bloody money. Mortgage-related fraud is up by five times since 2000.

BOSS: Says who?

QUEENIE: The FBI!

I have every right to try and make as much money as I can.

BOSS: Fuck you and your mother!

QUEENIE: Cunt!

BOSS: Well. That was fun.

QUEENIE: I quit.

BOSS: Yes.

QUEENIE: Scared?

BOSS: No.

QUEENIE: Yes. That's right. Don't look down.

10.

GOING SHORT

Lights spin/flash. Game Sting: 'Up'. Title on screens. CCTV.

QUEENIE: Heads or tails?

CASINO gets balloon pumps and round balloons.

QUEENIE: So. Now. The much-feared short. Nothing to it. You bet on a negative, that something bad will happen, and make lots and lots. In this case we're going to bet on which team's balloon will burst first. Because it's a short, it takes less time and has more bang for your buck.

Whoever has won the toss then starts the agreement of how much to bet. 'I bet your team two buckets we're going to burst first'.

So we need two more volunteers. One from each team to burst the bubble.

Get volunteers into position. Lights. Game Sting: 'Up'.

Ready? Steady? Go.

Music plays: 'Valerie'. Amy Winehouse. Mark Ronson. The balloon bursts. Lights. Game Sting: 'Down'.

CASINO: We have a winner. Well done.

Volunteers go back. Winnings are put into funds. QUEENIE and CASINO discuss who is winning so far. Theme music.

CASINO: That was the lovely Amy Winehouse.

QUEENIE: So we've put money in our funds. We've bet
 long. We've bet short. Next. We're going to
 hedge!

CASINO: And whoever wins this one decides our fate.

QUEENIE: Who will live and who will die.

11.

HEDGING

Title on the screens. Theme music. CCTV.

CASINO: Since it's the last game, let's make it more
 exciting and play for much more money.

QUEENIE: Yes. Let's be like the Bank of England and
 create lots of money.

CASINO: OK. Under each of your seats is a golden
 note.

*Audience retrieve gold notes from the floor under their seats as they do
this...*

QUEENIE: 267 billion pounds of cash change hands
 every year in the UK. Cash money is still
 pretty important to us.

CASINO: Other than the Bank of England there are
 seven commercial banks in Scotland and
 Northern Ireland issuing notes. These notes
 are guaranteed by the Bank of England with
 other special notes, called 'giants' and 'titans'.

QUEENIE: Monetary policy can be really quite poetic.

By now everyone should have their notes.

CASINO: A giant stands for 1 million pounds and
 a titan backs 100 million. These special
 notes, which are never let out of the Bank

of England, like all money, are valuable
because we all agree to believe they are.

QUEENIE: So. We're going to be like a National
Bank. We're going to quantatively ease this
financial situation. Put your hand on the gold
sheet and repeat after me, I believe, *(Audience
repeat 'I believe')* that this gold sheet *('that
this gold sheet')* is worth a bucket *('is worth a
bucket').*

CASINO: Can we call them Elves, or Dwarfs?

QUEENIE: Let's just call them buckets.

CASINO: Balloon blowers and balloon busters back up
please.

Volunteers are brought up and put into position.

QUEENIE: So we're going to hedge. That is we're going
to place two bets at the same time…long and
short together. One bet on which of these
two balloons will burst first. Another one on
which of these other two balloons will be the
biggest when that happens. And this time
you don't have to bet on your own team.

CASINO: Blindfolds.

He gives out blindfolds to the contestants.

No moral hazard here! They will not know
where the bets have been placed. We will
place our long bets first.

*They agree how much and place the bets by the balloon blowers. Short
bets have bigger buckets.*

To place our short bet we need an extra
volunteer to the stage. To place your short
bet you stand beside the balloon you think
is going to burst first. The difference is that

you can change your mind at any time until it bursts.

QUEENIE: Are we all ready?

I said. Are we all ready?

Good.

BOTH: Go!

Music: Mika. 'Grace Kelly'. The balloon bursts. Music stops. Lights spin/ flash. Game Sting: 'Down'.

If there is a tie:

QUEENIE: Well that's a tie. You know what that means.

CASINO: I sure do.

BOTH: A balloon off!

CASINO: OK. Everyone apart from balloon busters back to your seats.

QUEENIE: Since it's the last game do you fancy going 'all or nothing'?

CASINO: Team?

*Find out from team if they want to bet everything on one last game. They always do! If it isn't a tie, the Winner of the hedge can suggest one last go 'all or nothing'. But if their team say 'no' then that's fine. Go to *.*

QUEENIE: OK. Well. Do we want to change our buster?

CASINO asks his team the same. Players are set for final game.

CASINO: Are you ready?

QUEENIE: Steady?

BOTH: Go! Go! Go!

No music or lights.

*

WINNER: Right then.

LOSER: Right then.

WINNER: You lost.

LOSER: Yes.

The winner pours all the money into his or her suitcase. If one case is empty it is closed. Game Sting: 'Down'.

12.

PITCHING

Title on screens.

QUEENIE: We left the firm and set up our own fund. Together. Do you still want to play?

CASINO: Want in on the greatest game since Soros broke the Bank of England, since the Rothschilds backed Wellington with real-gold coins, since the value of a bushel of corn was scratched into mud…? You bet!

Loser of last game puts their case in the middle of the stage.

LOSER: But I'd had a nasty run of luck in a few silly, really rather childish games. I just didn't have much cash to put in, so I sold everything I could. My house. My shares. My car. And *(If QUEENIE is Loser.)* my mum put all her money in *(If CASINO is Loser.)* my wife and her family put all their money in.

WINNER: *(Drags or wheels money in the case to centre stage.)* I too had been paying some rather foolish games, but fortune had smiled on me this time.

But it wasn't enough. We needed more investors.

QUEENIE: Spring. 2007. Somehow. *Unbelievably!* Sub-prime mortgages seemed less risky. The ABX index was created in 2006 as an easier way to let investors short sub-prime. And it was

up. Didn't make any sense with our research. Houses were definitely not selling for asking price anymore. Mortgage lenders like First Century were going bankrupt. But strangely the banks on the other side of those swaps didn't think so. Not publically.

CASINO: So our trade was still a really hard sell.

QUEENIE: We were desperate for more money otherwise the bubble might burst before we could seriously get in the game.

CASINO: Queenie arranged lunch with our last hope, a very rich, very wise, old friend.

An audience member is given a bundle of golden notes that now represent 'buckets'. They are sat in the seat used for the Boss scene in the centre of the stage.

QUEENIE: *(Wearing a bowler hat.)* We took the boat to Chelsea. To inspire us. You think the hat's too much.

CASINO: You taking the piss?

QUEENIE: It was my father's…for good luck.

 Pitching a trade to a potential investor, I was taught, is like pitching a film to Hollywood… you've got to tell a good story.

CASINO: Your client is the hero, like Luke Skywalker.

 Luke is good. But must fight Darth, who is bad.

QUEENIE: You've got to explain that something is wrong right now. For example…you don't have enough money. Bad.

CASINO: No client ever has enough money.

QUEENIE: But we can make you rich. Also something is really wrong, there are tremors in the force…the bubble is about to burst, if you can bet the right way you'll make the most extraordinary amount of money.

CASINO: Short sub-prime mortgages now, while still, incredibly, no one believes that house prices will stop going up. This is the chance of a lifetime.

QUEENIE: Of course we don't mean *your* house. Not property *here*.

CASINO: If you've got any real estate south of the channel,

QUEENIE: or south of the river for that matter,

CASINO: Yes, sell that sharpish. But here?! If anything this will be a safe haven. Think about it if you're Greek where else are you going to buy a house?

QUEENIE: You call your client to adventure. 'Make your mark, on history.' They will probably refuse, at first. *(In the ear of the audience member.)* Say 'no'.

AUDIENCE: No.

CASINO: Refusal is very important. Not all heroes refuse of course. But the value of a good refusal is that it clarifies what's at stake. This isn't just about mortgages, this is your position vis-à-vis the whole global economy.

QUEENIE: Timing is everything.

CASINO: You can bet too early. This trade has negative carry, *(To audience.)* which means you're paying out, a relatively small amout, but still, investors don't like losing money for too long

and might pull out before your bet comes
good.

QUEENIE: But bet too late and the insurance will cost
 too much.

CASINO: And you've got to be able to get out in time.
 Remember no one knows what can happen
 in a volatile market and with this trade
 anything could happen.

QUEENIE: Together we will sap all the obstacles. Would
 the government secure all those homes?

CASINO: How are you going to unwind the trade?

QUEENIE: Could the companies that are holding your
 insurance go bust?

CASINO: Could you be left with nothing?

QUEENIE: It's risky. Yes. But think of all that money you
 could make.

 Then...and this is the killer move. This is
 the resurrection move. This is Luke hanging
 from an aerial on the Death Star.

CASINO: Cloud City.

QUEENIE: Whatever! Daddy cut your hand off, you're
 still a virgin, but then Hans, Leah, R2D2 and
 all that crowd rescue you...that's when you
 say...and you know what else we can do...
 we can go long on gold.

CASINO: Gold...that slow tick from another time.
 Before the first banks, or Babylonian tablets.
 Before pterodactyls, or trees or even the sea,
 there was gold.

BOTH: Say 'yes'.

AUDIENCE: Yes.

BOTH: 'Yes'!

QUEENIE: And many others soon followed. In 2008,
 hedge fund manager John Paulson's
 company made 20 billion dollars on this
 trade.

CASINO: He personally trousered 4 billion. In 2010
 he took home another 5 going long on gold
 against the US dollar.

QUEENIE: Do you think he actually wants the dollar to
 collapse?

CASINO: If it's going to go. Best be on the right side of
 the bet!

13.

ROADRUNNER SYNDROME

Title on screens. Music: 'Libertango'. Lights fade to a dark dance hall atmosphere. A glitter ball spins balls of light through the scene.

CASINO and QUEENIE dance the Argentinian Tango through this whole scene.

LOSER: We're looking at the Bloomberg screens all day long. Growth in the sub-prime market goes to 0%. But the market is still confident. Why don't they see what's happening?

WINNER: Roadrunner syndrome is when you run off a cliff so fast that you keep on going on just thin air. It's only when you notice the ground isn't there anymore that you fall.

LOSER: California. Look at California.

WINNER: It's started. It's happening. People are finally defaulting on their loans. People are losing their homes. We were right. We're going to be so rich. −2%.

LOSER: Our positions are strengthening all the time. If we sold everything today we'd make a billion.

WINNER: −3% Do you think we should sell?

LOSER: No.

WINNER: Just a little bit. I think we should sell just a bit. Just so that we know we've got it safe. It could go back up to 2% tomorrow and we'd lose like a billion pounds.

Down 4 now.

I can't stand it. I really think we should sell now. There's no way it's going to go on like this.

LOSER: 5%! You see. We've made 3 billion pounds and still nobody thinks anything is happening. Watch the news, walk in the streets, it's like we're in a parallel universe. They don't believe that it could crash, so even though it is actually crashing…it isn't… because no one believes it can. But that doesn't mean it won't.

WINNER: I'm selling. Sell. Please. Sell some of it.

LOSER: Just keep dancing.

WINNER: What if, I don't know, Bear Stearns goes bankrupt.

LOSER: Good. Someone will buy them up cheap. Wish it could be me.

WINNER: Bear Stearns has gone bankrupt.

LOSER: Wooo hooo.

WINNER: $132.20 a share, sold to JP Morgan Chase at 10.

LOSER: This is unbelievable.

WINNER: Was going to be only two!

LOSER: What did I tell you?!

WINNER: But what if more go bankrupt? What about our prime broker?

LOSER: It's fine. Don't worry.

WINNER: OK. Great.

 7% the BBB-rated mortgages have gone to zero. We won! We won!!!

LOSER: Yes. But. I think we should put it all back in. We've got some serious money now. We've got to put it all back in the game.

WINNER: No. I want to get out now.

LOSER: Don't you know how much you'll lose?

WINNER: I've got enough. Buy gold. You're a hedgie. Hedge. You're only betting short.

LOSER: There's more money here.

WINNER: I don't care.

LOSER: You're missing the trade of a lifetime.

WINNER: I don't care. I'm out.

LOSER: You can take your winnings. But you've got to leave me the fund. That's the deal.

WINNER: Fine.

The music stops. They stop dancing. Glitter ball lights go out.

LOSER: September 15th 2008. Lehman Brothers, the fourth biggest financial institution in the world crashed and took my whole fund with it. Lehman swept assets out of Europe into New York. In my opinion completely illegally. And I was just another creditor in a very long line. I had built a very rational case to speculate on chaos. Realised, in that

moment I…I just had never *believed* it could happen.

The Loser suddenly spasms forward in a dry retch. Game Sting distorted: 'Down'. Lights change to the Game State. Simon or the bouncer come on stage, put all the money and cases onto a hand forklift or in a 'wheely bin' and wheels it off.

14.

I SAID I WOULD KILL MYSELF

LOSER: It's not just that I lost all my money, but all my friends and family's money too. Of course I bankrupted all my clients and I was in debt to the tune of 200 million plus change. My family wouldn't speak to me… couldn't even look at me. I went to a bar. I ordered a whiskey sour…and then another one.

Title comes up on the screens. Loser in spotlight.

Loser takes a smart briefcase and opens it. They take out a black water pistol and then a large own brand bottle of tomato ketchup.

The City of London on a Sunday is dead quiet, a ghost town. You can hear a street sweeper's manky rotating brushes on his green cleaning machine…the bells ring. Oranges and lemons, Say the bells of St. Clement's. …I do not know, Says the great bell of Bow. Here comes a candle to light you to bed. And here comes a chopper to

A gunshot sounds quite like a balloon bursting…much louder than you think it's going to be, but also, there's something disappointingly dry and flat about it.

Mozart 'Requiem in D minor' fades in. Loser kneels and squeezes a lot of tomato sauce into his/her hands.

LOSER: The bullet passed smartly through my skull, through the left hemisphere and exited via

the occipital lobe. As the steel continued it was followed by

They smear an arc of red sauce across the screen while speaking. It is approximately the same shape as the US housing bubble graph.

blood and tissue which described perfect arcs in the air: Because gravity acted against the velocity of the mass: Because on Earth, what goes up, must come down.

Loser gets weaker and weaker. Winner in spotlight.

WINNER: Saturday 20th September, five days after the bankruptcy of Lehman Brothers, Henry 'Hank' Paulson the US Secretary of State for the Treasury had a vision as the sun went down. He imagined what could happen next. Dollars, Euros, Renminbi, Yen and Pounds could stop being money. Would have no more currency. Banks will freeze. ATMs stop. Wages. Trade, electricity, oil, the internet and TV just stop. And how to rebuild? All values could disappear in a day. What'll we do for the shirts on our backs, our land, our children? Who'll win the wars? What earth'll be left?

And then he was sick.

The US Secretary of State for the Treasury, ex-CEO and chairman of Goldman Sachs, with a personal fortune of approximately 700 million dollars was sick, he vomited down the death spiral of globalised capitalism and the White House chiefs of staff stood and listened to him gip.

LOSER: *(To their team and then 'the world'.)* I'm sorry. I'm sorry. I'm so sorry. I'm so

Loser dies/passes out.

15.

THE 5 STAGES OF GRIEF
DENIAL/ANGER/BARGAINING/
DEPRESSION/ACCEPTANCE/
IN NO PARTICULAR ORDER

The title comes up on the screen in stages (indicated by /).

The Winner goes to the Loser. The stage is shadowy. Eerie lights come up under the feet of the audience.

WINNER: *(To own team.)* What should I do? Should I try and save her/him? Do you want me to? Well?!

Response from audience.

(If yes.) But even if I can save her/him they'll never be the same again.

(If no.) But if I just let him/her die life will never be the same again.

Tosses a coin. Looks at it. Makes a decision.

You can't die.

Come on now. Stop mucking about.

You've made your point.

It was only supposed to be a joke. 'If we lose I'll kill myself' was supposed to be a joke. With the tomato sauce and the opera music.

You didn't think we really meant it did you?

Stupid. That's what this is.

(Puts hands in it.) Far too much.

You can't die. Not here. Not now.

Has an idea.

Listen. Listen. I'm going to call for help.
Right now. OK.

Dials an imaginary phone. CASINO/QUEENIE do their own sound effects of the phone.

Hello. Hello. Hello. Yes. I need help. Yes I'll
hold.

Hang on in there. I'm going to cut you the
deal of a lifetime.

Looks around. Someone comes to the phone.

Alistair? Darling. Wow. I didn't expect. We're
on the corner of Threadneedle and Hope
Street. Yes, it's a real place! S/he's dying.
What are you going to do about it? You can't
let Casino/Queenie die. I can't imagine life
without

OK. OK.

Great. Great.

Did you hear that? Help is coming.

That was Alistair and Gordon Brown, they're
with Bush and Paulson. They've just arrived
in the Oval Office right now. They're just
about to get into the Millennium Falcon and
pick up Lagarde, Sarkozy and Merkel on the
way. They're coming to rescue you.

If I wasn't a hedgie, if I was a real performance artist, I could construct a great story about how I brought you back from the brink. It would be so great.

And if everyone believed in it, then it would be true. Wouldn't it?

Where are they?

(To audience.) They're coming. We've just got to believe. Say with me. I believe.

AUDIENCE: I believe

WINNER: In Sarkozy.

AUDIENCE: In Sarkozy,

WINNER: Sarkozy, Darling and Brown,
 Bush and Paulson and Christine Lagarde
 They're all surely coming to town.
 To save the day, to pay the way
 To save the euro, the dollar and pound.

 Casino/Queenie you just hang on in there.
 Right.

Winner feels for a pulse.

Help is coming. Can you hear that?

Gently makes a nee-naw sound like an ambulance.

That's the falcon. They're coming and they're going to make you all better.

The Winner asks the audience to 'nee-naw' with him/her. Once the 'nee-naw' has started 'coma music' starts. The Winner and Simon lift the Loser onto the chair, which is tipped back into a gurney. They get them into a surgical gown and attach a microphone to them. The Loser is in a tight, brightly lit space. There are 'bip-bips' of a steady, slow heart being monitored.

79

WINNER: I'm not sure you all *really* believed I could do it.

Queenie/Casino didn't die. S/he lay in a coma.

After Lehmans went bankrupt the markets froze. The Irish government guaranteed all the deposits in the banks, which they didn't have enough money to do. Not by a long stretch.

Iceland went bust.

A month after Lehman's went down Alistair Darling and Gordon Brown announced in Parliament they would recapitalise, pour-money-into, RBS, HBOS and Lloyds, and the UK government took majority share holds in them. The same day Hank Paulson persuaded the nine largest US banks to take a government bailout.

Through all this s/he slept on.

Is it sleeping when your chances of waking up are so slim? Her/his heartbeat became more regular. The doctors said s/he'd be in a persistent vegetative state. But I just couldn't believe s/he wasn't in there somewhere. I knew s/he could hear what was going on. I began to hope s/he'd come back, might just open her/his eyes.

I sat by her/his side listening to the monitors. Would still hear their beep-beep as I walked home at night, past more empty shops than I've ever known and gangs of seething kids on their corners.

Headlines were all about how the banks didn't trust each other to lend, even with

the cash injections. It wasn't just a question of liquidity it was a question of trust. An old friend in Barclays told me about how they managed to avoid a government bailout partly by fixing the London Interbank Offered Rate. But the Libor scandal took four years to make it into four-inch typeset. In the meantime…

Nations who bailed out banks started to go bankrupt themselves. Ireland, Spain, Greece, Portugal, Italy. They negotiated bailouts from the European Central Bank and from the International Monetary Fund.

S/he slept on.

The biggest story was about a medicine called austerity. This is supposed to be the road to redemption after all the intoxicated, tax-evading, greedy, lazy, bad behavior.

But through it all I held on to the core of the story, its spine, that strand of faith that all the money was still real and true and would one day make sense again.

And Queenie/Casino was going to wake up. For sure.

The sound of the heart monitor only.

The Loser's eyes open with a fixed dead stare. Silence. The heart monitors have stopped. The Winner responds to the audience who will have noticed this activity now behind him/her. The Loser's head moves and his/her limbs start to twitch. The Winner notices the audience responding to this.

What? Is there something behind me?

Winner turns around to look. It just so happens that the Loser is not moving when the Winner turns.

> That's a sick human being. Have some respect, please! This isn't a fucking pantomime!

The Loser starts to drag him/herself out of the gurney. There is an almost painful, screeching sustained sound, but it is quiet.

> Come on! No. I'm not looking again.

Loser growls/cries. Winner turns. The painful sound gets louder and is underscored with a metal guitar playing a kind of slow pulse or 'heart beat'.

LOSER: Hungry.

Loser slowly moves towards the audience.

> Hungry.

WINNER: *(To audience.)* I'm sorry.

The Winner herds the Loser away from the audience with a metal rod. S/he puts the Loser into an iron neck brace, hooks the rod onto the neck brace so that the Loser can be kept beyond arm's reach and guided into the chair. The Winner then tapes the Loser's hands to the arms of the chair. Loser screams throughout.

WINNER: Queenie/Casino?

LOSER: Hungry.

 Bad deal.

 Must die.

WINNER: You're feeling a bit better? You've had a nasty turn. But it's all going to be alright.

Loser growls and struggles against restraints. Another element makes the painful sound and pulse feel more like music. So that the Loser is almost singing with it.

LOSER: Die. Death.

WINNER: S/he did open her eyes as you can see. But this is what the doctors refer to as an 'undead' episode or what I call 'doing a zombie'.

Winner gives Loser a sip of water from a child's non-spill beaker.

WINNER: No need for screaming now is there!

The Loser growls and sings 'Shoot me! Song of the Zombie' as the Winner explains what a 'zombie' is.

'Shoot me! Song of the Zombie':

LOSER: Shoot me in the centre of my brain. Shoot me. Shoot me.

shoot me right

in the fucking centre

In the centre of my fucking brain.

Shoot me in the centre of my brain. Shoot me. Shoot me.

Shoot me in the centre of my brain. Shoot me. Shoot me.

Can't live, can't die.

Let me go. Let my people go.

Before. Before.

Zombie wars begin.

Shoot me! *(Repeat)*

WINNER: 'Zombies' are mythical, fantastical, impossible, dehumanised human bodies. Born in the imagination of slaves. Born of people who were sold, severed from homes, lives and obligations. The recession in Japan led to what the West called 'Japanese zombie banks'. Frozen by debt. (Debts too big to write off.) For the sake of the creditors they stagger on. Feeding on tax payers' cash that will never be lent. Ever. For what? For the story. For the lie. We can't pay our debt

unless we grow, we can't grow unless we pay the debt… We know that our money is dead, but it can't be, so it must be undead.

Winner signals to 'Simon' to turn off volume on Loser's mic.

WINNER: No.

Loser screams without volume in the mic.

WINNER: No. I'm not having this.

You can just fuck right off.

You're being totally un-necessary and if you don't mind me saying…actually…over the top. Yes. I mean it. It's all a bit…much… don't you think? And…

I know what you're doing.

Loser screams again.

Stop doing that. I can't stand it.

OK. OK.

Winner signals that Simon can put it back on.

LOSER: *(Growls.)* You are a shit.

WINNER: You're just trying to make me feel guilty now.

Well. Let me tell you. It's not going to work. We both knew what the risks were. You lost. Tough shit!

Loser growls, dribbles.

WINNER: Here. *(S/he gets a hankerchief out from their pocket and wipes 'Zombie hedge fund manager's mouth.)* You're um…getting a bit dribbly there.

LOSER: *(Growls.)* Thank you.

WINNER: No problem.

Metal guitar pulse. Perhaps a metal version of theme music?

LOSER:	*(Still growling.)* 1.162 trillion…
WINNER:	UK pounds committed to bailout.
LOSER:	1.5 trillion…
WINNER:	UK Gross Domestic Product.
LOSER:	11 trillion pounds…
WINNER:	GDP of Eurozone.
LOSER:	9.5 trillion…
WINNER:	US GDP.
LOSER:	1.9 trillion…
WINNER:	Royal Bank of Scotland value in 2008 by assets.
LOSER:	28 trillion pounds…
WINNER:	The global market for Credit Default Swaps 2008.
LOSER:	44 trillion…
WINNER:	World GDP.
LOSER:	120 trillion…
WINNER:	Total Global Debt.

Winner feeds Loser with beaker.

> Some people think numbers are objective. Something-like the planets and physics. And there is something in that. Numbers as big as 120 trillion, that's 120, 000 000 000 000 are actually impossible to imagine. It is actually easier to imagine a zombie than that number.

Back to 'coma music'. Feeds Loser with soft baby food.

WINNER: With my pre-Lehman's winnings, I started
 shorting the Euro, and the US dollar, and of
 course I bought gold, not just gold futures,
 but actual gold. I dug a hole at the end of
 the garden. I mean. I didn't dig it myself. I
 paid some guys to come over and dig me a
 vault, under the swimming pool. I got three
 different firms to do it. So that no one would
 know I was doing it. Then, of course I was
 worried that I'd probably just advertised to
 two more firms more than I needed to that
 I was building a vault under my swimming
 pool, anyway. I hid it in my mum's cellar in
 the end.

 There's one bailout after another one.
 Impossible to read the market. There isn't
 a market anymore. Not one I recognise
 anyway. There's nothing I can do. I'm
 really confused. We can't print money
 forever, when we stop, asset value will fall.
 The bubble burst but the trades haven't
 unwound. Zombie banks refusing to lend
 to zombie households and somewhere, in
 the dark recesses of some bank's off-book
 balance sheet there's the monster that will
 finally come to the surface and take it all to
 zero.

 I've got depressed. Sitting up nights talking
 to you, (Loser) in my head. Sometimes, I just,
 you know, it's strange. I find that I say 'no'
 to a normal thing, like someone asks me if I
 want sugar in my coffee and I shake my head
 and then I can't stop shaking it. And I'm
 walking around all day, some days, with this
 shaky head. It's almost like I didn't win…you
 know.

Puts down food.

I didn't know how boring depression was. A pain that is tasteless and numb. I can't cry. I'm numb and guilty, and angry, for years, I can't accept and I can't let go.

It's not my fault.

Stop acting like a fucking loser!

S/he attacks him/her. They end up on the floor. The Winner on top of the Loser. The gun from the suicide is on the floor. The Winner reaches for it. Aims it at the head of the Loser.

LOSER: Kill me.

WINNER: No.

LOSER: Forgive my debt.

WINNER: No.

LOSER: Invest.

WINNER: No.

LOSER: Spend.

WINNER: No.

LOSER: What do you want?

WINNER: I just want it to be like it was before.

Loser screams.

WINNER: Oh. Shut up.

Winner takes away the microphone, sticks a piece of gaffer tape over their mouth and covers the Loser with a dust sheet. Coma music very distant.

In 2011 I take a trip around the world. How small it is, how uniform. Everyone looks the same: hungry, needy, weak, tired, scared.

Everyone feels the same: too hot, too cold, hungry, tired, scared.

87

Everyone wrapped in that porous skin.

Teeth quite blunt.

Even the fastest legs are far too slow.

I go to all the G20 summits: Washington, Paris, Cannes, Mexico.

For more than four years nothing happens. There are elections. There are riots. I come back to London. In 2012 the European central bank says that it will 'do what it takes'. Promises to underwrite all Eurozone nation states.

I decide to go back to work.

2013. Four and a half years since Lehman Brothers went bankrupt and the chain reaction is still unfolding. The ATMs are still working. The net still inter-ing. Some civil unrest, but still we're alright in the UK. And as I'm The Winner, I'm back to work. I don't want anything bad to happen to anyone, but if it's going to happen anyway I may as well churn some cash out of it.

16.

THE FUTURE$

Lights. Game Sting: 'Up'. Titles on screens. Theme music: slower.

OK. Final prize. (Name of bouncer) Can you bring up the final prize please?

Bouncer brings up a small box wrapped in gold paper on a red, plush cushion.

So back to work. Imagine you're all either asset managers or analysts at my usual 7 a.m. meeting. I'm going to propose a long and a short position based on what will happen in Europe over the next few years. You tell me what you think.

My team. As the winning team. You can choose if you want to go long or short on the future of Europe. You the losing team can 1) either take the other position (i.e short if they're long or long if they're short)

Or you can chose not to play.

This is the prize.

The small golden box is placed delicately on the floor. If anyone asks what is in it, the answer is 'a surprise'. (There's nothing in it.)

First. The long position. In three years Europe will become The United States of Europe. Frankfurt will become the 'Washington' of Europe because that's where the central bank for Germany, the Deutsche Bundesbank, is. The first president of the USE will be elected in 2015. Maybe it'll be Tony Blair? Maybe it'll be Gerard Depardieu? Public spending budgets for all euro countries will be set in Frankfurt. Whether you live in Nantes, Sicily, Athens or Lisbon your taxes will be addressed to Frankfurt.

The USE will start its life as the biggest economy in the world. Don't know what that means for democracy, or national identity, but if you want we can buy up property in Frankfurt now that'll churn big percentages if this happens. Anything in and relating to Frankfurt is a good bet in the new United States of Europe.

Second: How about we short the future of Europe? There's a limit to what a human body can stand. Bodies are finite. Debt is not. The crisis will break down into outright civil war in the streets.

As ordinary people in Portugal, Ireland, Italy, Greece and Spain along with many others find it harder and harder to make ends meet more suicide notes are left citing debt as the reason. Demonstrations become increasingly violent. Supermarkets are raided on a more and more regular basis by people who can't work, need to feed their families and have sold everything they have worth selling.

This is a risky bet. It could all go to zero.
But, if we can nip in there, short the right
national banks in the right order and convert
that money into a solid commodity like oil,
gold, land, bodies. We'll be rich beyond our
wildest dreams.

So what do you want to do? Go long or short
on the future of Europe?

*Listen to winning team's arguments. Facilitate the debate without adding
any persuasion. Get them to make a decision.*

And losing team. What do you want to do?
Are my team wrong? Why?/ Why not?

So, are you going to go long/short or step
back from the game?

OK. Let's say, for now, that this coin decides
the fate of Europe, because really it's as good
an analogy as any.

Heads are long. Tails are short. For the future
of Europe.

*Game Sting: 'Up'. Toss a coin. Game Sting: 'Down'. Announce the
outcome.*

Well. There you go. You win/lose.
Congratulations/commiserations. I'm going
to give you (member of winning team) the
prize. Make sure you share it fairly!

Pockets coin. Lights go out on the audience.

Of course there's always a chance that
something nice will turn up, out of the blue.
Something always does happen unexpectedly
and sometimes it is a good thing.

The thing I really hope will happen, is
not that oil is found in the Aegean Sea, or

even that a totally free, green fuel source is invented, although that would be amazing. What I would really love, in fact I think an ex-hedge fund manager-turned-performance-artist could die happy knowing that we all had that big chat we could have had in 2008, about what money is and what we want it to be.

Money is as much part of who we are as music and feasting, blood and carbon, language and belief. We make it. Literally. We can make it better.

Blackout. Game Sting: 'Down'. Lights up. Actors bow.

EPILOGUE:

RESURRECTION

Title on the screen. Theme music.

CASINO: Thank you for playing.

QUEENIE: You'll find underneath your seat an envelope.

CASINO: Inside each one there is a direction for finding treasure.

QUEENIE: You can't take the money with you, but if you follow these clues, you might find something nearby that is valuable and absolutely free.

CASINO: If you do find treasure please tell us at the web address enclosed.

BOTH: Thank you.

Bow again. Let the audience out.

WWW.OBERONBOOKS.COM